6/15/11
#24.95

# In the Bear's House

# In the Bear's House

# N. SCOTT MOMADAY

University of New Mexico Press | Albuquerque

© 2010 by N. Scott Momaday
All rights reserved. Published 2010
Printed in the United States of America
14  13  12  11  10      1  2  3  4  5

Library of Congress Cataloging-in-Publication Data

Momaday, N. Scott, 1934–
  In the bear's house / N. Scott Momaday.
     p. cm.
  Originally published: New York : St. Martin's Press, 1999.
  ISBN 978-0-8263-4839-5 (cloth : alk. paper)
  1. Bears—Literary collections. I. Title.
  PS3563.O47146 2010
  818'.5409—dc22
                                        2010019954

For Luke, Natachee, and Tai

# Contents

## Passages

# ACKNOWLEDGMENTS

For inspiration, for good advice, for their love and caring, I wish to thank the following: Barbara Glenn, Bernard Pomerance, Meir Ribalow, Doug Peacock, Bob Weil, and my daughters, Cael, Jill, Brit, and Lore

For his old nobility, his swerving loyalty, and his pursuit, with meticulous abandon, of life, I give thanks to Urset the Original.

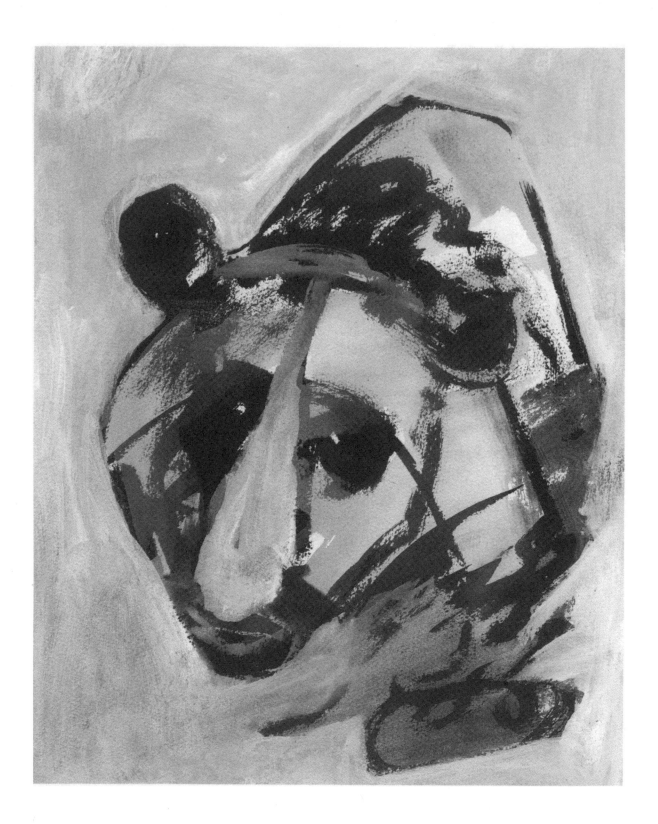

# INTRODUCTION

Let me say at the outset that this is not a book about Bear (he would be spoken of in the singular and masculine, capitalized and without an article), or it is only incidentally about him. I am less interested in defining the being of Bear than in trying to understand something about the spirit of wilderness, of which Bear is a very particular expression. Even Urset, who is the original bear and comes directly from the hand of God, is symbolic and transparent, more transparent than real, if you will. He is an imitation of himself, a mask. If you look at him very closely and long enough, you will see the mountains on the other side. Bear is a template of the wilderness.

I am acquainted with Bear, indeed more than acquainted. Bear and I are one, in one and the same story. My Indian name is Tsoai-talee, which in Kiowa means "Rock-tree boy." Tsoai, "Rock tree," is Devils Tower in Wyoming. That is where, long ago, a Kiowa boy turned into a bear and where his sisters were borne into the sky and became the stars of the Big Dipper. Through the power of stories and names, I am the reincarnation of that boy. From the time the name Tsoai-talee was conferred on me as an infant, I have been possessed of Bear's spirit. The Kiowas—whose principal religious expression was the Sun Dance and whose most ancient blood memory was

of the mythic darkness of a hollow log from which they emerged into the world—believe that the buffalo is the animal representation of the sun. Bear is the animal representation of the wilderness.

There are people in the world who would not wish to be in the world, were not Bear there as well. These are people who understand that there is no wilderness without him. Bear is the keeper and manifestation of wilderness. As it recedes, he recedes. As its edges are trampled and burned, so is the sacred matter of his heart diminished.

Bear, in these poems and dialogues, is of comprehensive mind and manner. He is wary, yet curious; old, yet playful; crotchety, yet serene; humble, yet wise. And like those originals whose presence we seem to require whenever it is given us, Bear is an impractical visionary. His eyesight is weak, but he sees beyond the edge of the world, beyond time; he watches with profound loneliness the arcing progress of his kinsmen in the night sky, curving to the solstices.

And one October I made a quest after Bear, in myself and in the wide night of the wilderness. For four days I camped on the east side of Tsoai and fasted. On the fourth night I felt strangely refreshed and expectant. The pangs of hunger that I had suffered through the day were gone. I felt a restoration of my body and spirit in the cold air. There was a perfect stillness around me. The great monolith, Tsoai, rose above me in phosphorescent haze, drawn like a tide by the moon. It bore a kind of aura for a time, and then, as the night darkened to black, its definition grew sharp. Ursa Major emerged on the south side of its summit, as if the two things were in the same range of time and space. Then the constellation rode over Tsoai, descending across its northern edge. It must have taken a long time, but it seemed a moment. And besides, I too was looking beyond time, into the timeless universe. Shadows deepened on the monolith, and in one of them appeared Bear, rearing in some fluent alignment with Tsoai itself, huge, indistinct, and imperturbable. I was fulfilled in some sense, neither frightened nor surprised. It was, after all, the vision of my quest, and it was mine, and it was appropriate. I came away more nearly complete in my life than I had ever been.

Some years later I ventured among a people for whom Bear is sacred. In western Siberia I was shown articles of the Khanty bear feast—the facial skin of a bear, like a mask from another world, the bear's paws, the sledge upon which the bear was borne to its shum, its house. In the presence of these things I felt their power. In their presence I understood something about Bear's transcendent spirit, how it is that Bear dances on the edge of life and death, crossing over and back again.

When the hunter has killed a bear, he tends carefully to its body. He anoints it; he removes its coat and replaces it. On a sledge he moves the bear's body to the edge of the village. There the people come to greet and welcome it. The bear is placed in its shum, its own house, where it can survey all the elements of the feast and preside over them. The hunter stands away, and the singer approaches. "Where are you going?" asks the singer. The hunter replies, "I am going to the bear's house." "Why, that is where I am going, too," says the singer. The singer begins his hundred songs, and there is wrestling and dancing and feasting far into the night.

Something in me hungers for wild mountains and rivers and plains. I love to be on Bear's ground, to listen for that old guttural music under his breath, to know only that he is near. And Bear is welcome in my dreams, for in that cave of sleep I am at home to Bear.

N. Scott Momaday
1998

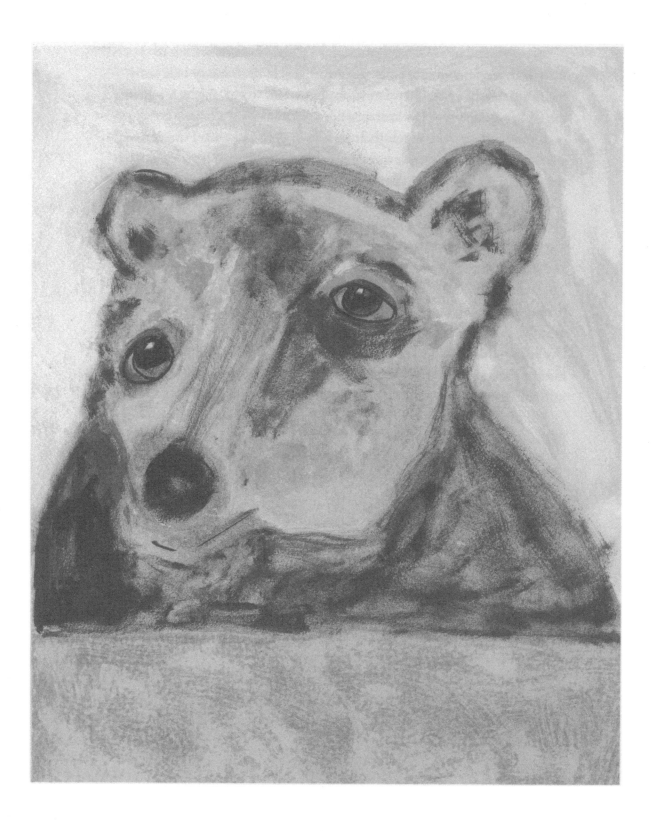

# THE BEAR-GOD DIALOGUES

▲ ▲ ▲

# YOU ARE, URSET. I AM, YAHWEH

*Undefined space. Two chairs under a light, perhaps a street lamp
or a Chinese lantern in a tree.* YAHWEH, *the Creator, is slouched
in one of the chairs, dozing. Enter* URSET, *the bear, very softly,
warily. He stands for a moment beside the empty chair, tentative,
ill at ease. He sits.*

URSET
Ah, ahem. Pardon, Great Mystery. Beg pardon.

(YAHWEII *stirs, stretches, looks up.*)

It is only I, Urset.

YAHWEH
Yes? What? Oh, yes, it is you, Urset. How are you?

URSET
Do you know me, then?

YAHWEH
Know you? How could I not know you, Urset. I created you.

URSET

Yes, yes, I have dreamed of that. I have dreamed that I came very small from your hands.

YAHWEH

So small. You were scarcely larger than a rat. I thought, when I saw you in your new corporeal being, that I had made some mistake, for I meant you to be formidable, and there you were, a wet rat. And yes, you did indeed come from these hands. These very fingers, these palms, the heels of these hands. I made a little ball of fur, wet fur—from something floating on the waters, as I recall—a knot of hair, a bit of drift. It was you! And, behold, you became formidable. I don't mind telling you, Urset, you are one of my showpieces. I am proud of you.

URSET

I was accomplished at your hands. I was wonderful, therefore, was I not? Am I not?

YAHWEH

The accomplishment was realized on time, according to plan. It was a simple thing, really—child's play.

*(pause)*

But there is something on your mind, Urset. Why do you come to me?

URSET

I am troubled. There is a heavy unrest in me, and I cannot easily speak of it.

YAHWEH

Are you not well?

URSET

Yes, on the whole I am well, thank you.

YAHWEH

Then—

URSET

I cannot easily speak of it. Had I words . . .

YAHWEH

Words, language, speech. That old, old matter of words. Yes, I might have known.

In the beginning was the word, you know, and I was there. I was the word. We are indivisible, the word and I. *I Am* is my name, and Jehovah and God and the Supreme Being and the Great Mystery. I hope that you will speak to me from your heart, Urset. And I hope that you will express your heart in fine, beautiful language. For I have an array of beautiful words about me, and elegant turns of speech. I delight in the language of my creatures. Your voice, Urset, as I remember, your voice is not unlike the voice of Man—*vox humana*. And that voice is one of the finest instruments of sound and meaning in the world—indeed the finest.

I would hear your voice, Urset, as I would hear rolling thunder, as I would hear the waves of the ocean crashing against the Cliffs of Moher, as I would hear the Fifth Symphony, as I would hear Charles Laughton reading from my story of Job or that of Shadrach, Meshach, and Abednego, as I would hear the lines of Homer, in which are sung the Trojan Wars. I would hear of it in words that play upon the sunrise, that resound in the caverns of the Malpais, that roll on the winds of the desert at first light. I would hear of it in words, Urset, in words that soothe and strike, that console and devastate, in words that descend into the blackness of the ocean depths and soar into the terrible brilliance of the sun. I would be astonished by your words.

URSET *(after a long pause, humbled)*
As I am by yours, Great Mystery. To tell you the truth, all words confound me. The word "rock" confounds me. "Tree" confounds me. "Child" confounds me. The word "sorrow" staggers me. The word "love" drops me to my knees. And yet silence resonates among all these words, and silence disturbs me most of all.

YAHWEH
I see that you are well enough, Urset. With these hands I placed you in the elements of earth, air, fire, water, and language and silence. You can talk to me, Urset. You may confide in me, and you may know that you exist in your name and in the words that tell your story, as I exist in my name and in the story in which all other stories have origin and being from the beginning to the end of time.

URSET
You are the Great Mystery.

YAHWEH
I am that I am. That is all. I am the object of your being. I am the storyteller and the story that inheres in your words and in your voice.

URSET
I am a creature made of flesh and blood and bone and hair. And you are a god made of words.

YAHWEH
You are, Urset. I am, Yahweh.

URSET
In my words and in my heart I am Urset. You are Yahweh.

YAHWEH
In your words and in your heart.

URSET
May I come again—with words?

YAHWEH
Come to me again with words, Urset.

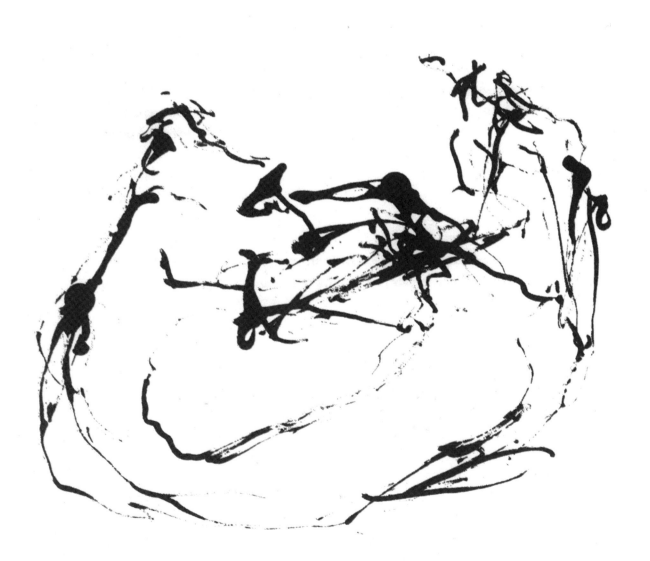

# BERRIES

URSET

Here. I brought something for us to eat.

YAHWEH

Ah, huckleberries. Thank you, Urset. Most kind.

URSET

I hope you like berries. We can be messy with them if you like, as I do. We can have purple lips and tongues. We can let the juice drip into our beards. Then everyone will know that we have eaten red-purple-blue, ripe, delicious, juice-squirting berries.

YAHWEH *(boisterous)*

Ha! They will think we have been discussing serious things, affairs of state, perhaps, strategies of war. Two old chiefs, in wise council, muttering, making faces. Our bibs will be stained as with blood! But, truly, Urset, we shall have done nothing more than eat berries.

URSET

We shall have eaten them with enthusiasm.

YAHWEH
With reckless abandon, with irresistible intent, in fury and frenzy.

URSET
In the manner of cubs.

YAHWEH
With the manners of cubs.

URSET
You see, these berries have ripened to a perfect sweetness in the sun—yonder, on the long slope.

YAHWEH
Yes, the thickets there. Wonderful berries. I like them very much indeed.

URSET
I like them very much, too, indeed.

YAHWEH
It is in your nature, if I may say so.

URSET
You know, I have been wanting to talk to you about that.

YAHWEH
About your fondness for berries?

URSET
Well, about my nature, actually—and yours, if I may be so bold—about the nature of . . . things.

YAHWEH
I see. Yes, Urset, that is an interesting topic. I think a good deal about the nature of things, their essential qualities and characteristics, their

deep aspects. But have you certain questions, specific questions? Here is a matter that wants some point, some focus, don't you see? It is possible to drown in the nature of things.

URSET

Berries. I am a bear, and it is in my nature, as I understand it, to relish berries, but is it in your nature to do so? I think not. Our friend Dog doesn't give a damn for berries. Neither does friend Fish. And I don't know where Man stands on the issue. I am a bear, and everyone knows I am a berry-eater and a fish-eater. I have killed a few dogs in my time, but I find their flesh distasteful. And the notion of eating a man is abhorrent to me.

YAHWEH

For now you are talking about cannibalism.

URSET

But I am not a man.

YAHWEH

You are not a man. But you are manlike.

URSET

And where is my nature in all of this? I am a bear, an old bear, the original bear, a crotchety old nuisance of a bear, and I am unreasonably fond of berries. Is it in my nature to sleep under the snow? Is it in my nature to hunger, to grow old, to die? And where is *your* nature in this, Great Mystery? I wonder. I do wonder.

YAHWEH

You are among those who are born, who grow old, who die. You are one of many, Urset, but you are also unique. Your nature is one of a kind. You are unique in your kind and in yourself.

URSET

As are you?

YAHWEH
As am I.

URSET
There are times when I am so lonely I want to die.

YAHWEH
I am always lonely, and I cannot die.

# PRAYER

YAHWEH *and* URSET *sit across a small table from each other.*
*On the table are cups and a basket of berries.*

YAHWEH
Urset, my old friend, I perceive that you are restless, that you wish to speak to me.

URSET
Yes, Great Mystery. I have something on my mind.

YAHWEH
You needn't be shy, Urset. Perhaps I have anticipated what you wish to say. That is an old habit with me. But I would like you, in your own voice, to tell me what is on your mind. Pray tell, what is it?

URSET
Pray tell, indeed, Great Mystery. Pray tell. To pray. I have been thinking of prayer.

YAHWEH
Yes? Ah, so. And how have you been thinking of it, Urset?

URSET
I have been thinking that I would like to pray, but I don't know how.

YAHWEH
Why, that's nonsense. Of course you know how to pray. You knew from the day you were born; I saw to that. It is a thing that I give to all my creatures.

URSET
But I don't know what prayer is. How can I know how to pray? Tell me, please, what is prayer?

YAHWEH
It is talking to God, Urset, simply that. And it is the silence from which your words proceed.

URSET
Am I praying now, Great Mystery?

YAHWEH
Even as we speak.

URSET
Do you pray, may I ask?

YAHWEH
Devoutly, unceasingly. It is what I do; it is what I am.

URSET
Would you be so kind as to make a prayer for me. Just now. For me.

YAHWEH
I pray that you are kept safe throughout this day, that you live as

wholly as you can, that you see things that you have not seen before and that more of them are beautiful than not, more of them delightful than not. I pray that you hold easily in your hands the balance of the earth and sky, that you laugh and cry, know freedom and restraint, some joy and some sorrow, pleasure and pain, much of life and a little of death. I pray that you are grateful for the gift of your being, and I pray that you celebrate your life in the proper way, with grace and humility, wonder and contentment, in the strong, deep current of your spirit's voice. I pray that you are happily in love in the dawn and that you are more deeply in love in the dusk. Amen.

    URSET
Amen.

    YAHWEH
Early this morning, Urset, when you walked along Frijoles Creek, what was it I heard you say?

    URSET
I said: The morning is crisp and bright. I expect something to define the air momently, perhaps the shrill cry of a rabbit or a wren. The water of Frijoles Creek runs southward through splinters of sunlight and patterns of shade. It runs without urgency, as I walk. It keeps the faster pace, but it and I proceed steadily, like the pilgrims of Chimayo, in our natures and in one nature, to the edge of the world. I hear among the stony churns of the creek words that I heard from an old man when I was young, *"Muy bonita día!"* Our laughter, his and mine, roves upon the cliffs of tuff close by. It is the first of all mornings, and it is unspeakably old.

    YAHWEH
Amen.

# DREAMS

URSET *and* YAHWEH *sit on a patch of grass. It is late afternoon, and there is a stillness all about. URSET yawns.*

YAHWEH
Yes, it is a lazy time, Urset, isn't it? This time of day—it is good for dreaming. You know, I have been dreaming, dreaming.

URSET
Yes? Dreaming of what? And by the way, what is dreaming?

YAHWEH
Dreaming is surely a way of seeing, of seeing with the mind's eye. More than that; it is the soul's perception of the world. It is an exposure made by the imagination, an involuntary record, a spiritual index, if you will. Do you know, I have been dreaming of the river that runs below.

URSET *(yawns again)*
Perhaps because of the fish we had for lunch. The river was cold this morning where I fished. Fishes were running fast, darting, jumping.

It was *good*. I could have scooped them up like grains of sand. We ate fourteen, I think.

YAHWEH

Yes, I had two. They were delicious, especially with mint and pine nuts. They are a fine aspect of the river, indeed, but I was dreaming of something else, actually. I was dreaming of headwaters, sources. I am fond of beginnings, Urset.

URSET

Beginnings. Becomings, Great Mystery. Genesis is your first and oldest masterpiece. Everyone admires it.

YAHWEH

Thank you. I dreamed it, you know, all of it.

URSET

You dreamed the rivers, the forests, the mountains?

YAHWEH

All of it, yes. The oceans, the deserts, the skies.

URSET

The animals?

YAHWEH

All of them, from the single cell to the blue whale. I dreamed Creation into being, all of it. You are a dream in my mind, Urset, and your dreams I have dreamed into your long sleep.

URSET

Yes. I have been meaning to talk to you about that. Why me? God knows (excuse me) I have that chronic long sleep. Why did you dream of such a thing? Such a thing as sleep. And what a curious word is "sleep." Slope, slip, slop, sloop, sleep, sleeeeeeeeeep. What sort of concept is sleep, anyway? It is a bit like death, if you ask me.

YAHWEH

Ironically. But it is a source—and a resource, Urset. In your case it is a great resource, and it empowers you beyond other creatures.

URSET

Of what is it the source, Great Mystery? I wonder.

YAHWEH

Of dreaming, Urset. You sleep, therefore you dream; you dream, therefore you are, and therefore, coincidentally, I am.

URSET

You confound me. Do you mean that I affirm you, then, in my dreams?

YAHWEH

Just so. In your dreams, Urset. In your sleep you prove the existence of God.

URSET

That is very efficient, I think.

YAHWEH

Just so. Just so.

URSET

I dream on a lesser scale than you do, I fear. In my long sleep I dream of berries and of the strange and beautiful things I have seen. I dream of high meadows to which my kin come in the spring and summer when the wind is fragrant with buckwheat and camas, and sweet roots are thick and tangled in the loam. I dream of lusty sows sauntering in the fields of flowers and of their cubs at play. I dream of clouds gathering at the summits and of rain descending in curtains on the dawn. I dream of hawks casting the shadows of their flight upon sunlit steeps. I dream of the moon riding and of leaves quaking on pale, speckled limbs, and darkness rising like water to the moon.

YAHWEH

In your long sleep I would have you dream, Urset. There is good in it.

URSET

Just so. Just so.

# STORY

*Morning in the meadow.* YAHWEH *sits at a small table, braced upon his arms, a mug of coffee at hand.* URSET *stands behind him, picking fleas from* YAHWEH's *hair. They make barbershop talk.*

YAHWEH
I created fleas with my thumbs, surely. And I must have got up on the wrong side of the bed that day. Humpf!

URSET
To tell you the truth, Great Mystery, some of us—the furry and the hairy among us, especially—have wondered about that. Dog actually speaks ill of you behind your back. And I'm told that he speaks of my "hirsute bear suit."

YAHWEH
He gossips in proportion as he scratches. He tells stories.

URSET
Yes, he tells stories. Ah . . . Great Mystery . . . what is it to tell a story?

YAHWEH

What? What is it to tell . . .

URSET

A story.

YAHWEH

Well, it is a telling. It is to tell of what has happened. It is a narration of events.

URSET

Yesterday I walked upon the mountain. Is that a story?

YAHWEH

No. A story must have a shape, a design, and it must have some consequential meaning. Yesterday Urset walked upon the mountain. So what? It is a declarative sentence. It is not a story. What happened as you walked upon the mountain?

URSET

Hmmm. I think I see what you are getting at. Here. Yesterday I walked upon the mountain. There I met a man who was desperately hungry. I had some food, and I gave it to him. He was most thankful.

YAHWEH

Yes, yes, Urset, you have told a story! Excellent!

URSET

Well, there isn't much to it, after all.

YAHWEH

More than you know, perhaps. The story you have told is a slight affair. It lacks those elements that are the essences of story—wonder, delight, belief, and grace. It isn't very interesting, if I may say so. But there is more to tell, I think.

URSET
I suppose it is barely a story.

YAHWEH
There are stories, and there are stories.

URSET
They are innumerable, I suppose.

YAHWEH
Well, there is only one story, after all. But there are many stories in the one.

URSET
The one story, it must be very old.

YAHWEH
It is older than I, for I am contained in it. It has neither beginning nor end in time.

URSET
Urset the hunter walked upon the mountain. There he met a man who was starving and was too weak to travel on. Urset gave the man food, and the man revived. He was entirely thankful, and he invited Urset to his home. The man's wife made a dish of fish parts in broth, and they feasted. The man's children sang and danced for Urset's amusement. And Urset the hunter was justly famous and widely acclaimed in the world. The end.

YAHWEH
Bravo! You astonish me, Urset.

URSET
Urset the hunter met a man . . .

YAHWEH
Wonderful.

URSET
They feasted, and the children sang and danced . . .

YAHWEH
Delightful.

URSET
Urset the hunter was famous and widely acclaimed in the world.

YAHWEH
It calls for a willing suspension of disbelief. Loudly.

URSET
Your turn, Great Mystery. Tell us a story.

YAHWEH
Urset the hunter walked upon the mountain. There he met a man who was desperately hungry. Urset gave the man food, but it was too little and too late, and the man perished. Urset the hunter grieved and was ashamed. He strove then to become a better hunter, indeed the best of all. From that time on he brought food to the man's widow and orphans, enough to sustain them, and the widow flourished, and the children grew up in wonder, delight, belief, and grace. And Urset the hunter was justly famous and widely acclaimed in the world.

URSET
It is a story well told, Great Mystery. That it were true.

YAHWEH
That it were not. All stories are true.

URSET

Yes, yes, it may be so. But do you know, Great Mystery, there is yet one thing about the story I do not understand. Oh, I think I know what wonder and delight and belief are and how they inform the story. All that is clear enough. But grace. I do not know what is meant by grace. Where in the story is a place for grace?

YAHWEH

Ah, that is the most important element of all. A story in which there is not the realization of grace is but a shadow, a shell, a thing without substance. Grace is the substance of story, albeit invisible and remote. Grace is the soul of story.

URSET

It is a presence without its mask.

YAHWEH

Or perhaps a mask behind which there is no presence.

URSET

There is nothing?

YAHWEH

A mask of words behind which there is nothing, only silence, a perfect stillness.

URSET

Grace.

# EVOLUTION

*YAHWEH and* URSET *sit in chairs facing each other. Behind them is the statue of a man, perhaps a Greek philosopher or an athlete.*

URSET
Yes, Great Mystery, Man, too. He talks as much as the dogs do.

YAHWEH
With greater measure, I hope. Not incessantly.

URSET
Measure, indeed. Sometimes he speaks poetry, *poetry*, mind you. It is very pleasant to hear, but it seems to me, well, unnatural, a bit elevated, if you see what I mean—high-toned, lofty, almost exclusive. . .

YAHWEH
It is the highest of all languages, Urset, higher even than mathematics. It is on a plane with music. And yes, Man is the keeper of poetry.

URSET

Is it because, as the dogs say, Man is more highly evolved than the rest of us?

YAHWEH

Yes. In certain respects and in general—he is more highly evolved.

URSET

Why is that, I wonder?

YAHWEH

My timetables. Man is on a faster track than the other animals. At the same time that his brain developed to its present size, he developed a vocal mechanism of some distinction. The two things enabled him to possess language and speech—and poetry.

URSET

Language. How did it happen? How did language begin?

YAHWEH

Oh, the children made it one day. Poor Man, he had been trying so hard to talk, for such a long time. Then the children went out and played together. At the end of the day they had possession of language. They went home and said to their parents, "This is what you have been trying to say."

URSET

Language is child's play.

YAHWEH

There you have it.

URSET

This business of evolution, Great Mystery, what will come of it?

YAHWEH

The end, surely. Nothing will come of it, as it has come from nothing.

URSET

But we shall have had a good run.

YAHWEH

Good beyond the telling.

# THOUGHT

URSET *is sitting on the ground, deep in thought.*
YAHWEH *approaches, stands over him.*

YAHWEH
Well, there you are, Urset. Pardon. Do I intrude?

URSET
Oh, oh, Great Mystery! I did not see you coming. No, no, indeed, you do not intrude. I was just daydreaming, I suppose. I was quite lost in thought.

YAHWEH
Lost in thought. Yes, yes, Urset, *there* is a dark tangle, to be sure. We all get lost in thought. To be lost!—what travail. Last week, I think it was, I went for a walk, and the next thing I knew, I was lost among the stars. There are so many, you know. The night sky is an intricate and dangerous place if you get into it—like the ocean. From a distance it is very beautiful, but it has depths that are unimaginable even to me.

URSET
Is thought such a place?

YAHWEH
The most dangerous of all.

URSET
Do you say so?

YAHWEH
I say so, indeed. That is the point.

URSET
What do you mean?

YAHWEH
I say, I speak, I talk. Thinking is talking to oneself. Thought is made of language—a sky full of glittering words, if you like. There are galaxies of words in the mind, you know. Just think, Urset, if you close your eyes, you can see the Milky Way writ large, as it were, in language—in letters and alphabets and words, in glyphs and ciphers, in paragraphs and passages and pages—a broadside of the universe, if you will. Celestial graffiti.

URSET
It may be that I have a small mind, Great Mystery. I cannot think of galaxies of words, much less stars. Ursa Major is enough for me. Seven stars, two or three of the first magnitude, I think.

YAHWEH
Appropriate, too. Quite so. Tell me, Urset, in what thought were you lost?

URSET
Well, it was a thought—let me see if I can remember. It was the thought of life everlasting. Yes, that was it.

YAHWEH

Hmmm, I see. I must say, Urset, that is a very large thought even for so large and learned a bear as you. No wonder you got lost.

URSET

Life everlasting. Everlasting life. I don't know what to make of it. It seems a contradiction in terms. Everlasting life, life everlasting. No, I cannot accept such a notion. Oh, I know it works for you, Great Mystery (what doesn't work for you?), but not for me. I am born, I grow old, I die. I am the very meat of morality, perishable to a fault, to a fare-thee-well.

YAHWEH

Shame on you, Urset. Did I not give you an immortal soul?

URSET

I don't know. I am confused. I am lost in thought. Do you know, Great Mystery, I am unaware of my soul, of the soul you say I have. It has no appearance, no heft, no breath that I have ever heard, no touch that I have ever felt. But even if I have a soul, I don't know that I wish to live forever in that fragile disguise. I am a great bear! How could such a weightless transparency support me? How could such a nonentity be equal to my, my bearing? I think I want to persist in my corporeal being.

YAHWEH

Why do you doubt your immortality?

URSET

In the caves are the bones of my children, Great Mystery. I go there and look upon them, and I shudder and weep. What are these lifeless, brittle remains? A while ago my children were warm and full of motion. They danced and they sang and they climbed trees and they plunged their corporeal selves into the rivers. What happened to them? Where did they go? I want them to come back to my camp. I want to play, to roughhouse with them. I want to make them squeal,

even in pain. I want them to react to me! I want to lay my strong hands upon the strong shoulders of my sons and daughters. I want to touch them, and I want to feel the solid resistance of their flesh. I don't want to touch the shadows of their having been. I have no more need of their shadows or their souls than I have of my own. Oh, I think of them! I think of them, how they were and were going to be. And I am lost in thought.

YAHWEH
You will find your way, Urset. It is ordained.

URSET
Those are mere words, are they not?

YAHWEH
Words, not mere words. Man has thought of an idiom: You cannot have your cake and eat it too.

URSET
That is true to my experience, especially where berries are concerned. But I think these are words, too, after all.

YAHWEH
Hold that thought.

# TIME

YAHWEH *and* URSET *sit at a table, facing each other.*
*There is a tea service; they sip from dainty cups.*

YAHWEH
As you were saying, Urset . . .

URSET
I was saying that lately I have a sense of urgency, Great Mystery. I
believe that my time is drawing near.

YAHWEH
Mortality weighs upon you, does it? Oh, my friend, that is an affliction
I did not intend.

URSET
It happens. I am old. I have lived a long time.

YAHWEH
Let me tell you something, Urset, and try to hear what I am saying,

for it may ease your mind. Time is neither long nor short. It does not draw near, nor does it recede into the distance. It is present, that is all. The present is all there is.

URSET

But I am witness to the past, some part of it, and surely there is a future. Everyone says so. Everyone believes in it. There will be another sunrise, and another, and another, in the fullness of time.

YAHWEH

Artificial tenses, the past and future of which you speak, mere extensions of the present. I am. You are. Time is.

URSET

Time passes. This we know, for we read our clocks, and we see that time works change upon us.

YAHWEH

There is no passage of time, Urset. There is only passage *through* time.

URSET

I am not consoled to imagine that there is no future. You see, I have always thought of the future as a time of fulfillment, a better time, a time when the fruits of all our labors should ripen to a great enrichment, a bountiful age—if not for me, then for my children— heaven on earth, I suppose.

YAHWEH

There was a paradise in what you call the past. It is the place where Man was born, as the theologians have it. It was overdone, I think—too much greenery and fragrance. It was a kitschy corner of time, an antique anteroom of the present. Do you find consolation in the notion of paradise? You are alive in the present, Urset. Be consoled by that. You hold the moment in your hands. You can make

something of it, if you will. Be alive to the communion of time and chance. The present may not be all you want, but it is what you have, and it is enough to sustain you.

The present. It is a finite field of finite possibility, but see what is there. Beyond it there is nothing, only the infinite vacuum of the future, so called, but see. Now. There are flowers in the field and butterflies among them. As one of my poets put it, "We live in an old chaos of the sun," but "Sweet berries ripen in the wilderness."

URSET
Berries? Berries? I begin to see the strength of your argument, Great Mystery.

YAHWEH
My creatures have made of time a difficult concept, especially Man.

URSET
It is rather simple, isn't it?—as you explain it. The present is all there is, but it is enough. Is that it? Have I got it? Time is. Notice, I speak in the present tense.

YAHWEH
Eloquently, Urset. But there is more to it, I'm afraid.

URSET
More?

YAHWEH
Eternally more. We must consider time in context. We have not spoken of eternity.

URSET
Ah! I see where you are going. You are going to speak of time and timelessness, aren't you?

YAHWEH

Precisely. You see, Urset, we sit apart, you and I. On your side of the table there is time. On mine there is no time; there is eternity. And yet we both are here. We both inhabit the present.

URSET

It is a table, for God's sake (excuse me). Do you mean to say, Great Mystery, that just here, in the center of this table, time comes to an end?

YAHWEH

Just so, just so.

URSET

But, but . . .

YAHWEH

You must excuse me, Urset. I have a meeting; I'm out of time.

# WRITING

YAHWEH, *the Creator, and* URSET, *the original bear, engage in conversation.* YAHWEH *has entered upon the stage to find* URSET *bent over a table ruminating and applying the stub of a pencil to paper. He is both concentrated and frustrated. After mumbling a few words of unintelligible exasperation he becomes aware of* YAHWEH's *presence.*

URSET
Oh! Oh, it's you . . . I mean, hello to you, Great Mystery.

YAHWEH
I see that you are preoccupied, Urset. I don't mean to disturb you. Let me leave you to your work, if work it is.

URSET
Oh, no, please stay, Great Mystery. You do not disturb. I am just scratching here, as you see. I am very pleased to see you, indeed. Indeed!

YAHWEH
Why, what is the matter, Urset? You seem distressed.

URSET
I . . . I am caught up in a mighty struggle, a futile struggle, one I cannot hope to win. Oh, I had no idea what I was getting into!

YAHWEH
But you appear merely to be writing—scratching, as you say. Your struggle, Urset, is it with words?

URSET
My futile struggle, my mortal struggle, my intense agony, my utter and everlasting and hopeless and unspeakable trauma, my mother of all wars, is with words, Great Mystery. Oh, merciless, unforgiving words!

YAHWEH
I had no idea. How on earth did you get into such straits?

URSET
I was watching a book.

YAHWEH
You were . . . you were watching a book?

URSET
Yes, during prime time.

YAHWEH
And?

URSET
And it took possession of me. I couldn't put it down, as they say. Oh, I tell you, it was an ambush, Great Mystery, an unholy thing. I hadn't a bear's chance in a berry thicket. Do you do exorcisms?

YAHWEH

Never mind that. But I really don't understand, Urset. Why, it sounds like a good experience to me, a literary experience.

Let me tell you, when I first read Genesis, I was enthralled.

URSET

Oh, don't misunderstand; the reading was all right, delightful, even. But then I suddenly got the idea that I could scratch wonder upon a surface— *write*. Why not, I said to myself. What is more commonplace in the world than pages full of words?

A book is a cinch, a piece of cake. I will toss off a few pages before lunch—more than a few. I will scratch a novel, a play, or an epic poem by tea time, then have a good nap. The notion of a book tour entered my mind. Well! Well, then the assault, the verbal massacre. Oh, I fled the field in tatters, in shame, in ursine humiliation. Why, oh why didn't you tell me about the hostility, the treachery, the sheer cruelty of words?

YAHWEH

Hush, Urset. So you have discovered that words have power, even the power to oppose you who employ them. That is a fortunate and fundamental discovery. Be glad for it. It enables you to live your life more intensely, to your greater enrichment, your fulfillment.

URSET

But, but my struggle . . . my heroic hurt . . .

YAHWEH

My good friend, you have suffered a case of the writer's frustration, that is all. There is nothing terminal about it.

Everyone who writes, even if it's only an entry in one's diary, a letter, a high-school book report, encounters it. It was the same when you learned to talk—that earliest foray into language—though you probably don't remember it.

URSET

Oh, I can talk. I'm a mighty good talker. I can talk up a storm. I can talk to beat the band.

YAHWEH

I know, Urset. I know.

URSET

And I fancy I can tell a story with the best of them.

YAHWEH

Tell me, have you thought of the difference between telling a story and writing one?

URSET

Er . . . in a word, no.

YAHWEH

There is a critical difference. One, the telling, involves the voice, the human voice, the breath of the soul. The other involves visible symbols, the incising (or scratching) of signs upon a surface, the abstract inventions of the mind.

Both are indispensable. But the first is inestimably older than the second, and it is more expressive of our whole being. It gave origin to the second. The second has gained a certain prominence in our time. It has given us the books that contain the great literatures of all literate cultures. But there would be no books without the telling first, the immediate breath of creation. I am speaking of the two great traditions of language, Urset, the oral and the written.

URSET

When you came into the room, I was butting heads with the written tradition.

YAHWEH

Just so. And in that tradition you have mastered the art of reading.

But you are at an early, tentative stage of writing. You are poised in the balance.

URSET

If you don't mind, I think I will stay there. I rather like being poised.

YAHWEH

Readers are not necessarily writers. There is a distinction, a factor that distinguishes scratching from writing. Or writing from *writing*.

URSET

What? Say again.

YAHWEH

It is a factor that I imposed upon evolution in my salad days. I'm not sure I remember the formula, but no matter, I am rather proud of it. It is a kind of random absolute. It might be called genius, or chance, or the gift of God, or the scratch factor. It is the face of the unknowable and the mask of wonder.

You see, Urset, today when you dared to write, you found words alien to your expectations, full of resistance, indeed ominous. You are not alone in that. But there are others—not many, a distinct minority in this history of the world—who take delight in that holy dread, who find words irresistible, prismatic, profound, wonderful beyond imagining. They take them and scratch them into miracles of meaning, of infinite possibility and grandeur.

Think, Urset, just think of a Shakespeare or a Dante or a Cervantes dreaming a dance of words and shaping the glide and flow of them upon the page! How magical! How nearly divine the rendering of such majesty and music and truth! Think of Melville conjuring the leviathan. Think of Joyce at the window of his mind's eye seeing snow falling into the mutinous Shannon waves. Think of Emily Dickinson, alone in that upstairs room with only her mind and her coffer of words. It is a simple equation, mind and words, but it is enough to engender immortality.

URSET
Great Mystery, can you teach me to write?

YAHWEH
I can teach you to write, Urset, but I cannot teach you to write *Moby Dick*.

# BASEBALL

*The stage is spare—two chairs and a table between them.* URSET,
*the original bear, sits in one of the two chairs. He is slouched
over, his chin on his paw, in the attitude of Rodin's* The Thinker.
*Indeed, he seems lost in thought. Enter* YAHWEH, *the Almighty. He
regards* URSET *for a long moment.*

YAHWEH
Hello Urset, my good fellow!

URSET
*(shaken from his reverie)*
Uh, oh . . . yes. Good day to you, Great Mystery. Uh, how are you?

YAHWEH
Well, better than you are, from the looks of you. You seem out-
side yourself, Urset, disconnected, even morose. Is it so? Can I be
of help?

URSET
Oh, no. Thank you. It's just that I am trying to understand something—

a common, everyday sort of thing, but it eludes me. It nearly confounds me.

> YAHWEH

Oh, dear, I wonder what that can be.

> URSET

Baseball.

> YAHWEH

Baseball . . . Baseball?

> URSET

Baseball. You know, played with bats, a ball, gloves . . .

> YAHWEH
> *(exasperated)*

Oh, for heaven's sake! OF COURSE I know what baseball is. I was a pretty fair shortstop in my day. I taught Ernie Banks everything he knew, if I do say so myself.

> URSET

My children, my little brood of bears, they are forming a *team*. Their enthusiasm is boundless. Why, they even have a name for themselves.

> YAHWEH

Don't tell me . . . the "Cubs."

> URSET

I really don't know why they can't be a football team. They are bears, after all. They are thick and furry. And they are already accomplished at assault and battery. It is their nature. It is what they do. But *baseball!* Baseball is a game of swat, catch, and tag—better played by housecats, if you ask me. Do you know, I caught one of my roly-polys doffing his cap to a sloe-eyed cheerleader on

the sideline! Imagine!—one of mine, doffing his cap. Oh, it was an unworthy thing. And on top of it all . . .

YAHWEH

Yes, Urset, on top of it all, what?

URSET

They want me to be their coach, their manager. Oh, the ignominy! The shame!

YAHWEH

Enough! Enough, Urset. You protest too much. Clearly you don't understand what baseball is, what its essential aspects are, how they constitute a mythology of the mind and heart.

URSET

Mythology? Mind and heart? Baseball?

YAHWEH

You see, Urset, you must understand that baseball is not merely a competition, not merely a contest of strength or speed or stamina or chance, not even a contest of skill. It is the enactment of some ancient ceremony of the soul. Why are we enchanted by sport, inspired by sheer physical exertion? Well, for one thing, it is beautiful to see. Imagine Secretariat lining out on a fast track, Edwin Moses skimming the hurdles, or Michael Jordan hanging for an impossible time in midair. Imagine the graceful choreography of a perfect play at Wrigley Field, the blur at low trajectory of a small white sphere rocketing from third to first *in the nick of time*. I am talking about the truly extraordinary, Urset, the unique performance, the accomplishment of physical expression that is realized for its own sake, artistry that neither proffers nor requires justification.

URSET

I hear you, Great Mystery, and I am moved. The cubs, my cubs in the dugout, they hear you, and they are moved.

YAHWEH

And they see the geometric formality of baseball before them, the parameters, the symmetry, the definition of the field: lines, measures, the precise alignment of the pitching mound and home plate, a diamond, the angles of which are *exactly* ninety feet apart. Ah, but in this mathematics there is an allowance for aberration, chance, luck. From park to park the outfield fences lie at different distances from home plate. In all sacred ceremony there must be the variables that permit of some departure from the norm, that admit of miracle or chaos, of the unknown, of story, if you will.

URSET

I will. But to tell you the truth, Great Mystery, I don't think my cubs are into miracles, chaos, and the unknown. They want to play baseball. They dream of becoming the stars and heroes, but they don't care for the mythologies, I think. We are practical bears. If I am to become their manager, I must teach them how to win, how to please the crowds. I must increase attendance above all. I will place midgets at the plate. I will hose down the base paths. My first plan is this: I will have the vendors dispense not beer and soda pop, but champagne! Ha, what will you say to that?

YAHWEH

I will say, is the champagne properly chilled?

URSET

Why, yes, of course . . .

YAHWEH

If you chilled it, they will come.

*Note: Let us move ahead.* URSET *has become a successful coach-manager. The Cubs have won many more games than they have lost. Their fans appear to be jubilant, but there is in them a holy dread. This condition is clearly reflected in* URSET *himself.*

URSET

We approach the wall of truth, Great Mystery. On this side the struggle. On that side the triumph, immortality.

YAHWEH

On the far side perhaps there is nothing. Perhaps the triumph of which you speak is contained in the struggle and not elsewhere.

URSET

Perhaps. My cubs have learned a few things about baseball, and so have I. For example, we have learned that baseball engenders a loyalty that is ineffable. And it is conjoined with suffering. Oh, I'm not talking about the physical suffering only—the sprained ankles, the broken fingers and ribs, the ruins of aborted slides and collisions at home plate. I'm talking about the festering wounds in the soul, the loyalty that is nourished by loss, the cancer that invades hope. I have learned that a great and indispensable part of baseball consists in suffering. Never mind the agony of defeat. There is a truer agony in victory. Victory exacts the greater price, for it is dear. Many more games are lost than are won. Many more players are consigned to oblivion than to fame. I tell you, we must fear victory, for it is a country we do not know; it is a terrain full of pits and stones. It is a luxury we cannot afford. This I have learned.

YAHWEH

You astonish me, Urset. You astonish God.

URSET

And then there are the fans.

YAHWEH

Yes, ever the fans. *Their* suffering is acute, endemic, exquisite. For their loyalty is divine. Like Merlin they are imprisoned in rings of air, and the air is laden with the scents of peanuts and crackerjack. Oh, they are a blessed lot. Their pain is delicious. Their cause is bright and futile.

URSET

Their destiny lies in the blur of the small white sphere, the relay from Tinker to Evers to Chance.

YAHWEH

Oh, yes, YES, Urset! *There* was a trinity! Oh, my Tinker! What a shortstop! I taught him everything he knew.

URSET

We are winning, my cubs. We win two, we lose one. And the more we win, the harder it is to lose. It hurts. It is pain unrelieved. And you always lose. It is in the order of things.

YAHWEH

Yes, it is in the order of things. The sun rises and sets. The stars are in place. In the newspapers, Urset, in the sports pages, you find the words "victory" and "defeat." They are mirror images of each other.

URSET

Yes, I know. Win and lose, two sides of the same coin. Yet one is coveted and the other loathed. It is natural, isn't it—the desire to win, to achieve victory?

YAHWEH

Win . . . victory. They are not quite the same thing, Urset.

URSET

No?

YAHWEH

No. I must say, I like the word "victory"—and the concept. The Greeks were big on it. It had to do with valor and bravery and a kind of nobility. It is a proud, honorable word. "Win" has the odor of lotteries and door prizes. Victory is hard to come by. It has to be earned. Winning is almost gratuitous. Victory is beyond winning. Men, from the beginning of my Creation, knew this, many men and

many women. They have always run, not for the winning only, but for spiritual expression. It is a kind of prayer. Baseball at its best is an expression and a celebration of the spirit, Urset.

URSET

Ah . . . you know, G.M., you could, if you had a mind to . . . *fix* it . . . so that my cubs never lose . . .

YAHWEH

Bear, bear, bear. I love you. Bear, my first bear, my miscreant.

URSET

Yahweh to Urset to Chance! Take me out to the old ball game.

# POEMS

▲ ▲ ▲

# THE BEAR

      What ruse of vision,
escarping the wall of leaves,
      rending incision
into countless surfaces,

      would cull and color
his somnolence, whose old age
      has outworn valor,
all but the fact of courage?

      Seen, he does not come,
move, but seems forever there,
      dimensionless, dumb,
in the windless noon's hot glare.

      More scarred than others
these years since the trap maimed him,
      pain slants his withers,
drawing up the crooked limb.

      Then he is gone, whole,
without urgency, from sight,
      as buzzards control,
imperceptibly, their flight.

*Stanford, 1963*

# SCAFFOLD BEAR

*"Bears love the taste of whiskey"*
ESTHER NAHGAHNUB

Here in this cave of sleep
I know of an animal on the slope;
No one has seen it,
But there are stories.
Juan Reyes dreamed of it too.
It reared against a moonlit cloud
And sundered the dream.
A young girl spoke of it with wonder,
Having heard it scoop the river for its food.

My own story is this:
A good man killed himself.
The next morning a bear, stripped of its hide,
Lay on a scaffold in a range of trees,
Bleeding, breathing faintly.
Its great paws had been removed.
The bear spoke to someone there, perhaps to me,
For in this cave of sleep
I am at home to bears.

*Tucson, 1983*

# THE CORPOREAL BEAR

You are too large for a quatrain.
You must be fitted in such verse
As will your prominence contain,
Lines neither narrow, neither terse,
et cetera, et cetera.

*Jemez Springs, 1998*

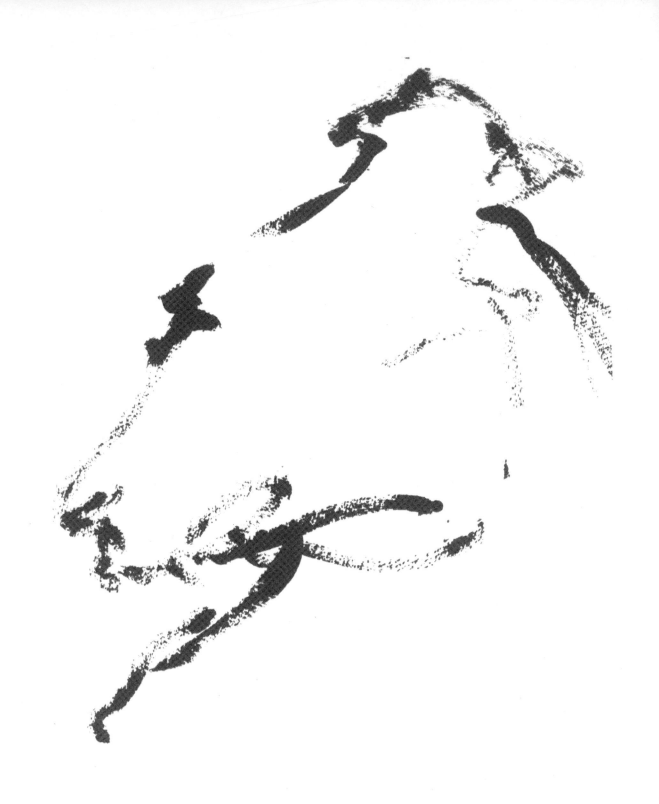

# A BEAR IN BRONZE

*For Luis Jimenez,*
*A drawing for a fountain*

I pose, engender fear, parade my wounds.
My deeds are worthy of my boast. The sounds
Of strife become me, and my head is high.
I stand upright and piss on passersby.

*Jemez Springs, 1997*

# THE BLIND ASTROLOGERS

Now, at evening, we hear them.
They sheer and shuffle, cracking
branches and heaving the air.
Always shyly they appear.

In radiance they take shape
faintly, their great heads hung low
on arcs of age, their dull eyes
compassing the murky moon.

They sway and impress the earth
with claws. They incise the ice.
Stars of the first magnitude
pulse the making of their dance.

They ascend the ancient bridge
and lay fishes in our way,
so to feed us and our dogs.
Along the green slant southward

the blind astrologers blaze
the long traces of our quest.
They lead us, dead reckoning
by the suns they cannot see.

We regard them with wonder,
fear, and sorrow. They mutter
and cry with voices like ours;
they mime a human anguish.

When they take their leave they fade
through planes and prisms of rain
into the drifts of story,
into calendars and names.

*Tucson, 1994*

# PRAYER FOR WORDS

*"My voice restore for me"*
   Navajo

Here is the wind bending the reeds westward,
The patchwork of morning on gray moraine.

Had I words I could tell of origin,
Of God's hands bloody with birth at first light,
Of my thin squeals in the heat of his breath,
Of the taste of being, the bitterness,
And scents of camasroot and chokecherries.

And, God, if my mute heart expresses me,
I am the rolling thunder and the bursts
Of torrents upon rock, the whispering
Of old leaves, the silence of deep canyons.
I am the rattle of mortality.

I could tell of the splintered sun. I could
Articulate the night sky, had I words.

*Tucson, 1995*

# THE PRINT OF THE PAW

It lies among leaves. Indeed, a leaf, fast and broken, is impressed in the heel's deep hollow. The leaf is yellow and brown, and brittle at the edges. The edges have been crushed; there is a fine dust of color, like pollen, in the mold. Deeper than the heel's hollow are the claw's piercings. They are precisely placed in the earth as if the great beast moved with meticulous grace. The toes turn inward, perhaps to describe like a keel the center of gravity upon which a great weight is balanced. Were I to construct a model of this bear, based upon this single print, it would turn out to be a mythic and wondrous thing. It would be a cipher, a glyph, a huge shape emergent on the wall of a cave, a full figure in polychrome splotches of red and yellow in black outline. And I would be an artist of the first rank on this occasion, if on no other, for I should proceed directly, in the disinterested manner of a child, from this nearly perfect print of the paw. And all who should lay eyes upon my work would know, beyond any shadow of a doubt, how much I love the bear whose print this is.

*Jemez Springs, 1997*

# THE REMEMBERING

They converge in water
that is absorbed in the dark needlework
at their feet.
Light smokes above them,
piercing the high weave of pines.
The brake is dark but for the low illumination
of old snow and bracken and the hoar of the hair
above their withers.
She squats, her throat wound round
and her thick haunches bowed,
her broad head borne back beneath her shoulder.
Her feet roll in mud, and her eyes behold
his vague advance, his long looming.
From her daybeds she has risen in his nostrils,
aching there.
He takes her, rotating his forearms upon her flanks,
laying his jaw hard along her spine.
She rocks under his weight—
yield and brace, yield and brace, is staggered—
and her breath, ravelled with his breath,
remembers wind and rain rolling,
and thunder far away rolling.
An image, like remembrance too, shimmers in his brain:
a great fish, urgent from the bottom,
rises fast in the channel, breaks the water
and becomes still and iridescent
in the hard hold of the air,
then plunges into darkness again, and again.

*Tucson, 1994*

# URSA MAJOR

How is it he keeps the night, God?
*Alone, in universal space.*
Is his the loneliness of time?
*And being. Night defines his place.*

How is it he rides the void, God?
*Alone, among the threads of light.*
Is his the loneliness of death?
*And being. He inters the night.*

How is it you performed him, God?
*Alone, across a firmament.*
Is his the loneliness of grief?
*And being, and a sacrament.*

*Tucson, 1995*

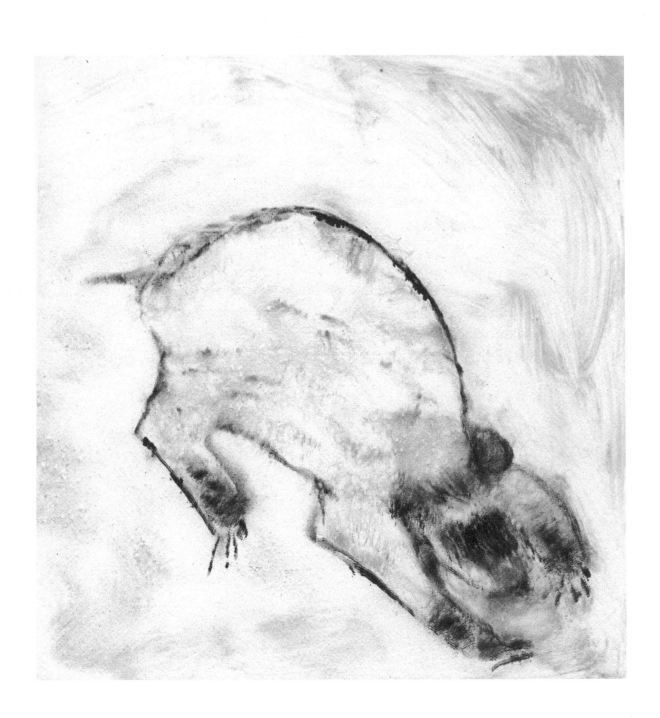

# TO AN AGED BEAR

Hold hard this infirmity.
It defines you. You are old.

Now fix yourself in summer,
In thickets of ripe berries,

And venture toward the ridge
Where you were born. Await there

The setting sun. Be alive
To that old conflagration

One more time. Mortality
Is your shadow and your shade.

Translate yourself to spirit;
Be present on your journey.

Keep to the trees and waters.
Be the singing of the soil.

*Santa Fe, 1995*

# TRES CAMPOS

### 1. To Incise

These claws that score the sweating ice,
sheer instruments that chart the chase
in ciphers simple and precise,
describe forgiveness, grief, and grace.

### 2. The Feeding Field

Across the dark ravine, there is the dead,
Your hunger's waste that lately was bright red,
Now smudged with rot and scented through with dread.
You are almost bewildered in your stead;
Your spirit lingers, lonely, where you fed.

### 3. The Selfsame

my breath
to your breath

my eye
to your eye

my tooth
to your tooth

my hand
to your hand

we are each other
we have one understanding
of the stars

*Jemez Springs, 1997*

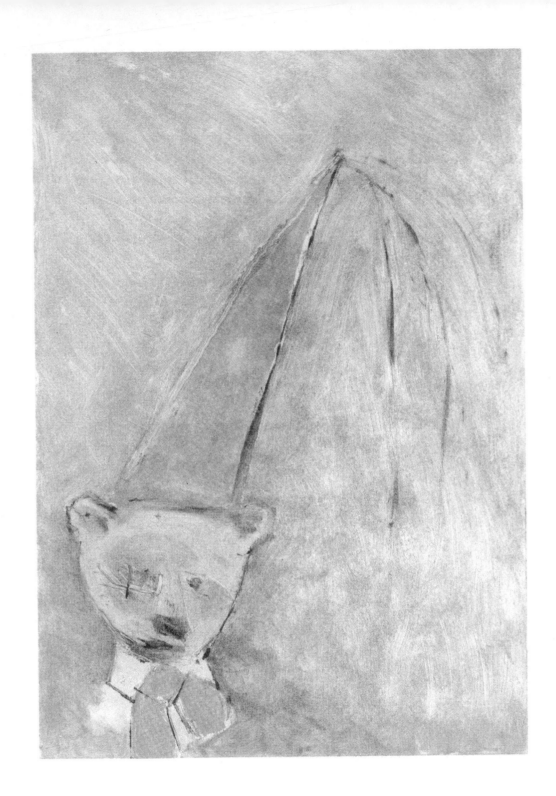

## MOSCOW CIRCUS

In the winter twilight I walked away from the huge wedding-cake building in which I lived that year. The great, illuminated red star on its central spire shone faintly through the falling snow. Other walkers in overcoats and fur hats moved in silent formation with me. They were all indistinct; they might have been the shades of Borodin or Stalingrad. I got on the train at Universitet, sat down in the last carriage, removed my gloves, and began to read a slender volume of poems by Akhmatova. At Park Kultury the bear got on, and I lost my place in the book. He sat opposite me two spaces to my right, next to the door. I could not help staring at him, for I had never seen a creature so well turned out, nor circumstances more unlikely than these. No one else paid him any mind. If he was aware of my rudeness he was gracious enough not to show it. I tried to memorize him. He was the size of a sun bear, but his conformation was that of *Ursus horribilis*. His eyes were very black and very bright. His expression was nearly impenetrable. It was impossible to tell his age; he might have been young or old or in between. There was an aspect of the infantile about him, as there is about the ancient. On the third finger of each hand he wore a diamond. On his feet were immaculate white spats with buttons the black of his eyes. At his throat was a wide white collar and a large, floppy red bow tie. On his head was a tall blue cone, decorated with silver and gold glitter and erupting in multicolored streamers. In his paws, the wheel placed precisely across the furry groove of his lap and the saddle above his right ear, he held a gleaming unicycle. It seemed a most delicate instrument, and his attitude toward it one of profound propriety and respect. His whole demeanor enchanted me, and I missed my station. I got off at Dzerzinskaya and watched the train lurch away. In his window the bear had turned to look at me. Did he smile? Was he trying to memorize me? His was the last face I saw as the train vanished, carriage by carriage, in the black tunnel. And then did I dream him in the ring, in the brilliant spot of light? He pitched and reared and spun on the unicycle. He

tossed his head, wielding the cone of his hat like a sword, the beautiful streamers roiling, describing the burning, scintillant air. His prismed paws flailed upon the swell and roll of adulation, and he rotated his forearms like a human being.

*Santa Fe, 1995*

# NOTES ON A HUNTING SCENE

The hunt was ended and the hunter cold.

The far incline of fields and taiga extended to the moon, and the bear lay lifeless on a sledge.

Unaccountably, a woman began to laugh, and her laughter was like ice rattling in a tin cup. Had it been frozen, it would surely have glittered like candlelight upon icons.

The hunter trudged to the fire. A wolf howled in the west, and cold was the condition of the world at midnight. Owls were ornamental, and they were ominous. Behind the hunter's eyes were geometries of time and distance, intersections of sorrow and fatigue. He imagined his grandfather fishing through the ice. A fish, when it was hurled into the air, froze instantly and made an iridescent arc upon the sky.

The bear had crept on the edge of the taiga, rearing now and then to sniff the wind. When the end came, it slumped slowly down and made its bed. It died at a moment between the final rattle of its breath and the awful silence that followed. The moment cannot be fixed exactly in the range of time.

The woman drank from a bottle and laughed again.

In the village pain was preserved in the way that embers are kept alive. Life did not persist without pain. Somewhere it is written.

The bear lay lifeless on the sledge. Sooner or later the singer would come, and everything would have its place in the relief of ritual.

*Tobolsk, 1997*

# SUMMONS

*For Yuri Vaella*

Where is the bear doctor? Where is he?
I have come from the north, and I thirst.
I have come from the east, I hunger.
I have come from the south, I am tired.
I have come from the west in great need.
Where is the bear doctor? Where is he?
In my life I have known the bad things.
In my life I have known the good things.
I have come from the dawn, and I sing.
I have come from the dusk, and I dance.
I have come from the mountains to die.
I have come from my home to go forth.
Where is the bear doctor? Where is he?
Who will outfit me for my journey?

*Moscow, 1997*

# THE KHANTY BEAR FEAST

*For Yeremei Aipin*

Consign me to ritual
on pretexts of sacred kinds.
Unbutton my coat, and have
children pay me their respects.
Fasten my eyes with bright coins.
Let me hear the singer say,
"Whose house is this?" And reply,
"Behold, this is the bear's house."
And I shall preside with wild,
disinterested kindness.

*T'umen, 1997*

# REVENANT

You are the dark shape I find
On nights of the spilling moon,
Pale in the pool of heaven.
You are spirit, you are that
Which summons me and confirms
My passage. You know my name.
Your ritual dance remarks
The crooked way between me
And the very thing you are:
Mask, essence, and revenant.
You are, as you ever were,
The energy that sustains
My mere despair. And always
You are that dark shape I find.

*Tucson, 1997*

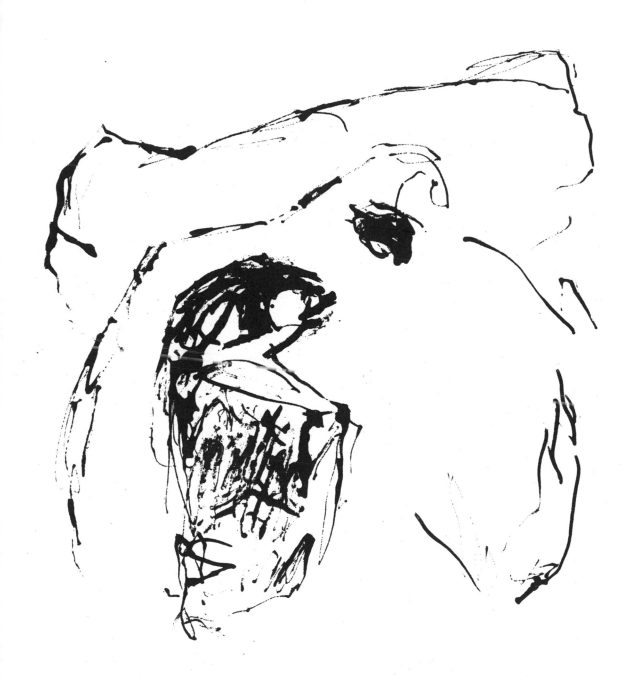

# WINTER SOLSTICE AT AMOXIUMQUA

*For Barbara*

In the village, *ketha'me*
in the canyon, *ketha'me*
in New Mexico, *ketha'me*
a fine snow is falling.

The flakes swirl
as if to discover a wind
purling upon the laden limbs.

To the west
the canyon wall, blacked out,
is nonetheless present and looming.

Upon it lowly remain
the ruins of Amoxiumqua.
Imagine a bear standing
in a street of that ancient town.

There is no moon,
no light by which to see
the fine snow falling.

In the dull memory of its blood
the bear discerns the swirling flakes,
and points of cold
sting its nebulous eyes.

Then, when its wild brain
can no longer conceive of the sun or moon,
the shifting fog becomes almost luminous,
and it conjures, as a gift, the village below.

*Jemez Sprinys, 1997*

# MEDITATION ON WILDERNESS

In the evening's orange and umber light,
There come vagrant ducks skidding on the pond;
Together they veer inward to the reeds.
The forest—aspen, oak, and pine—recedes,
And the sky is smudged on the ridge beyond.
There is more in my soul than in my sight.

I would move to the other side of sound;
I would be among the bears, keeping still,
Not watching, waiting instead; I would dream,
And in that old bewilderment would seem
Whole in a beyond of dreams, primal will
Drawn to the center of this dark surround.

The sacred here emerges and abides.
The day burns down, the hours dissolve in time;
The bears parade the ancient continent
As silences pervade the firmament,
And wind wavers on the radiant rime.
Here is the cave where wilderness resides.

*Jemez Springs, 1997*

# CAVE PAINTING

From this fissure in the rock
you almost emerge in time.
Yet you are not wholly here
in seventeen thousand years.
What did the artist reckon
of infinite composure,
of your struggle to be born
in the geologic night?
Stillborn in pigment, you keep
the posture of becoming
and are informed by that dread
of the darkness that is art.

*Altamira, 1995*

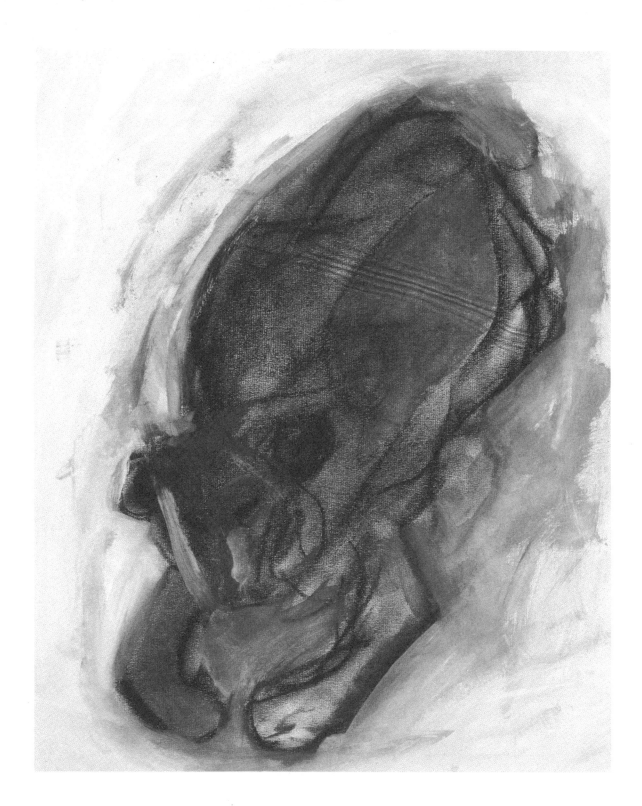

# PASSAGES

▲ ▲ ▲

# THE BEAR HUNT

HE WAS A YOUNG MAN, and he rode out on the buckskin colt to the north and west, leading the hunting horse, across the river and beyond the white cliffs and the plain, beyond the hills and the mesas, the canyons and the caves. And once, where the horses could not go because the face of the rock was almost vertical and unbroken and the ancient handholds were worn away to shadows in the centuries of wind and rain, he climbed among the walls and pinnacles of rock, adhering like a vine to the face of the rock, pressing with no force at all his whole mind and weight upon the sheer ascent, running the roots of his weight into invisible hollows and cracks, and he heard the whistle and moan of the wind among the crags, like ancient voices, and saw the horses far below in the sunlit gorge. And there were the caves. He came suddenly upon a narrow ledge and stood before the mouth of a cave. It was sealed with silver webs, and he brushed them away. He bent to enter and knelt down on the floor. It was dark and cool and close inside, and smelled of damp earth and death and ancient fires, as if centuries ago the air had entered and stood still behind the web. The dead embers and ashes lay still in a mound upon the floor, and the floor was deep and packed with

clay and glazed with the blood of animals. The chiseled dome was low and encrusted with smoke, and the one round wall was a perfect radius of rock and plaster. Here and there were earthen bowls, one very large, chipped and broken only at the mouth, deep and fired within. It was beautiful and thin-shelled and fragile-looking, but he struck the nails of his hand against it, and it rang like metal. There was a black metate by the door, the coarse, igneous grain of the shallow bowl forever bleached with meal, and in the ashes of the fire were several ears and cobs of corn, each no bigger than his thumb, charred and brittle, but whole and hard as wood. And there among the things of the dead he listened in the stillness all around and heard only the lowing of the wind . . . and then the plummet and rush of a great swooping bird—out of the corner of his eye he saw the awful shadow which hurtled across the light and the clatter of wings on the cliff, and the small, thin cry of a rodent. And in the same instant the huge wings heaved with calm, gathering up the dead weight, and rose away.

All afternoon he rode on toward the summit of the blue mountain, and at last he was high among the falls and the steep timbered slopes. The sun fell behind the land above him and the dusk grew up among the trees, and still he went on in the dying light, climbing up to the top of the land. And all afternoon he had seen the tracks of wild animals and heard the motion of the dead leaves and the breaking of branches on either side. Twice he had seen deer, motionless, watching, standing away in easy range, blended with light and shadow, fading away into the leaves and the land. He let them be, but remembered where they were and how they stood, reckoning well and instinctively their notion of fear and flight, their age and weight.

He had seen the tracks of wolves and mountain lions and the deep prints of a half-grown bear, and in the last light he drew up in a small clearing and made his camp. It was a good place, and he was lucky to have come upon it while he still could see. A dead tree had fallen upon a bed of rock; it was clear of the damp earth and the leaves, and the wood made an almost smokeless fire. The timber all around was thick, and it held the light and the sound of the fire

within the clearing. He tethered the horses there in the open, as close to the fire as he could, and opened the blanket roll and ate. He slept sitting against the saddle, and kept the fire going and the rifle cocked across his waist.

He awoke, startled, to the stiffening of the horses. They stood quivering and taut with their heads high and turned around upon the dark and nearest wall of trees. He could see the whites of their eyes and the ears laid back upon the bristling manes and the almost imperceptible shiver and bunch of their haunches to the spine. And at the same time he saw the dark shape sauntering among the trees, and then the others, sitting all around, motionless, the short pointed ears and the soft shining eyes, almost kindly and discreet, the gaze of the gray heads bidding only welcome and wild good will. And he was young and it was the first time he had come among them and he brought the rifle up and made no sound. He swung the sights slowly around from one to another of the still, shadowy shapes, but they made no sign except to cock their heads a notch, sitting still and away in the darkness like a litter of pups, full of shyness and wonder and delight. He was hard on the track of the bear; it was somewhere close by in the night, and it knew of him, had been ahead of him for hours in the afternoon and evening, holding the same methodical pace, unhurried, certain of where it was and where he was and of every step of the way between, keeping always and barely out of sight, almost out of hearing. And it was there now, off in the blackness, standing still and invisible, waiting. And he did not want to break the stillness of the night, for it was holy and profound; it was rest and restoration, the hunter's offering of death and the sad watch of the hunted, waiting somewhere away in the cold darkness and breathing easily of its life, brooding around at last to forgiveness and consent; the silence was essential to them both, and it lay out like a bond between them, ancient and inviolable. He could neither take nor give any advantage of cowardice where no cowardice was, and he laid the rifle down. He spoke low to the horses and soothed them. He drew fresh wood upon the fire and the gray shapes crept away to the edge of the light, and in the morning they were gone.

It was gray before the dawn and there was a thin frost on the leaves, and he saddled up and started out again, slowly, after the track and into the wind. At sunrise he came upon the ridge of the mountain. For hours he followed the ridge, and he could see for miles across the land. It was late in the autumn and clear, and the great shining slopes, green and blue, rose out of the shadows on either side, and the sunlit groves of aspen shone bright with clusters of yellow leaves and thin white lines of bark, and far below in the deep folds of the land he could see the tops of the black pines swaying. At midmorning he was low in a saddle of the ridge, and he came upon a huge outcrop of rock and the track was lost. An ancient watercourse fell away like a flight of stairs to the left, the falls broad and shallow at first, but ever more narrow and deep farther down. He tied the horses and started down the rock on foot, using the rifle to balance himself. He went slowly, quietly down until he came to a deep open funnel in the rock. The ground on either side sloped sharply down to a broad ravine and the edge of the timber beyond, and he saw the scored earth where the bear had left the rock and gone sliding down, and the swath in the brush of the ravine. He thought of going the same way; it would be quick and easy, and he was close to the kill, closing in and growing restless. But he must make no sound of hurry. The bear knew he was coming, knew better than he how close he was, was even now watching him from the wood, waiting, but still he must make no sound of hurry. The walls of the funnel were deep and smooth, and they converged at the bank of the ravine some twenty feet below, and the ravine was filled with sweet clover and paintbrush and sage. He held the rifle out as far as he could reach and let it go; it fell upon a stand of tall sweet clover with scarcely any sound, and the dull stock shone and the long barrel glinted among the curving green and yellow stalks. He let himself down into the funnel, little by little, supported only by the tension of his strength against the walls. The going was hard and slow, and near the end his arms and legs began to shake, but he was young and strong and he dropped from the point of the rock to the sand below and took up the rifle and went on, not hurrying but going only as fast as the bear had gone, going even in the bear's

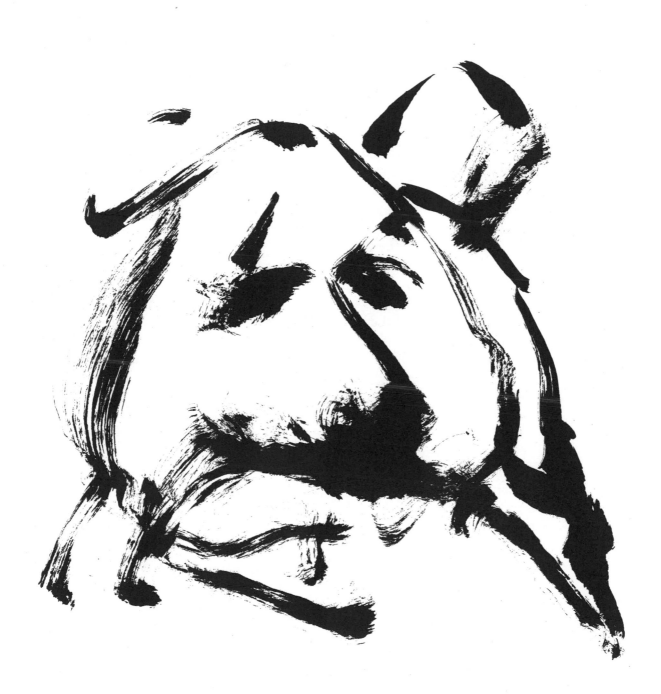

tracks, across the ravine and up the embankment and through the trees, unwary now, sensible only of closing in, going on and looking down at the tracks.

And when at last he looked up, the timber stood around a pool of light, and the bear was standing still and small at the far side of the brake, careless, unheeding. He brought the rifle up, and the bear raised and turned its head and made no sign of fear. It was small and black in the deep shade and dappled with light, its body turned three-quarters away and standing perfectly still, and the flat head and the small black eyes that were fixed upon him hung around upon the shoulder and under the hump of the spine. The bear was young and heavy with tallow, and the underside of the body and the backs of its short, thick legs were tufted with winter hair, longer and lighter than the rest, and dull as dust. His hand tightened on the stock and the rifle bucked and the sharp report rang upon the walls and carried out upon the slopes, and he heard the sudden scattering of birds overhead and saw the darting shadows all around. The bullet slammed into the flesh and jarred the whole black body once, but the head remained motionless and the eyes level upon him. Then, and for one instant only, there was a sad and meaningless haste. The bear turned away and lumbered, though not with fear, not with any hurt, but haste, slightly reflexive, a single step, or two, or three, and it was overcome. It shuddered and looked around again and fell.

The hunt was over, and only then could he hurry; it was over and well done. The wound was small and clean, behind the foreleg and low on the body, where the fur and flesh were thin, and there was no blood at the mouth. He took out his pouch of pollen and made yellow streaks above the bear's eyes. It was almost noon, and he hurried. He disemboweled the bear and laid the flesh open with splints so that the blood should not run into the fur and stain the hide. He ate quickly of the bear's liver, taking it with him, thinking what he must do, remembering now his descent upon the rock and the whole lay of the land, all the angles of his vision from the ridge. He went quickly, a quarter of a mile or more down the ravine, until he came to a place where the horses could keep their footing on

the near side of the ridge. The blood of the bear was on him, and the bear's liver was warm and wet in his hand. He came upon the ridge and the colt grew wild in its eyes and blew, pulling away, and its hoofs clattered on the rock and the skin crawled at the roots of its mane. He approached it slowly, talking to it, and took hold of the reins. The hunting horse watched, full of age and indifference, switching its tail. There was no time to lose. He held hard to the reins, turning down the bit in the colt's mouth, and his voice rose a little and was edged. Slowly he brought the bear's flesh up to the flaring nostrils of the colt and smeared the muzzle with it.

And he rode the colt back down the mountain, leading the hunting horse with the bear on its back, and, like the old hunting horse and the young black bear, he and the colt had come of age and were hunters, too. He made camp that night far down in the peneplain and saw the stars and heard the coyotes away by the river. And in the early morning he rode into the town. He was a man then, and smeared with the blood of a bear. He shouted, and the men came out to meet him. They came with rifles, and he gave them strips of the boar's flesh, which they wrapped around the barrels of their guns. And soon the women came with switches, and they spoke to the bear and laid the switches to its hide. The men and women were jubilant and all around, and he rode stone-faced in their midst, looking straight ahead.

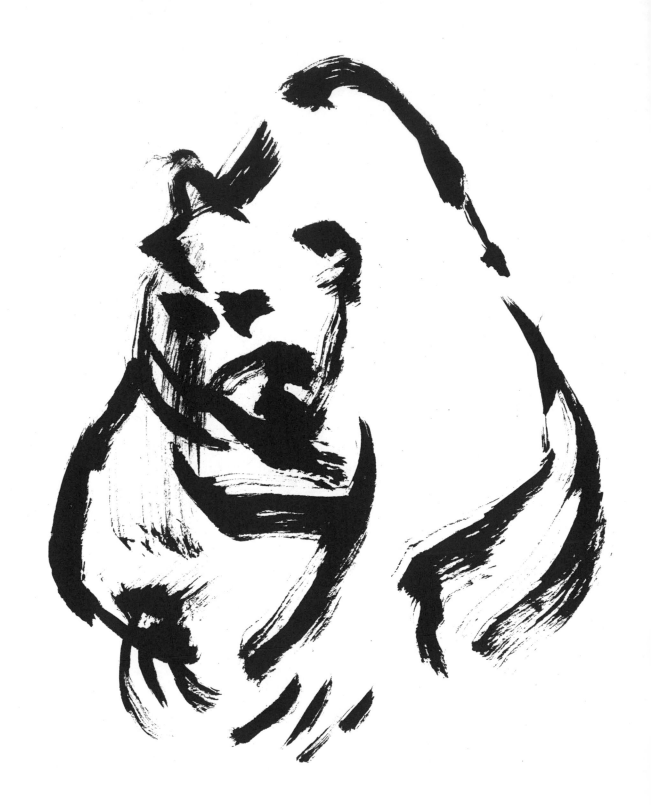

# THE TRANSFORMATION

Eight children were there at play, seven sisters and their brother. Suddenly the boy was struck dumb; he trembled and began to run upon his hands and feet. His fingers became claws, and his body was covered with fur. Directly there was a bear where the boy had been. The sisters were terrified; they ran and the bear after them. They came to the stump of a great tree, and the tree spoke to them. It bade them climb upon it, and as they did so it began to rise into the air. The bear came to kill them, but they were beyond its reach. It reared against the trunk and scored the bark all around with its claws. The seven sisters were borne into the sky, and they became the stars of the Big Dipper.

KIOWA STORY OF TSOAI

▲ ▲ ▲

*The boy.*
*The boy ran.*
*The boy ran after his sisters. There was a bursting of the boy's heart.*
*He stumbled and gasped and stood still. The cries of his sisters*

*pierced his brain like a madness. He caught his breath or not his own breath, really, but the breath of something other and irresistible and wild. The ground was almost cold. Dust floated in the long, slanting rays of the sun. Somewhere a raven called. And when the boy looked up his sisters too were standing still, off among the trees, and their faces were pale and contorted with fright. In their eyes was certain disbelief—and certainly love and wonder. And they began to run again, and again he took up the chase.*

▲ ▲ ▲

*No one ever saw the sisters again. Only on the day they left the camp did anyone speak their names. Their names were soon forgotten, though the sisters themselves were remembered, not as individual children, with particular appearances and manners, but collectively. They had become* the little sisters to whom it happened. *For the first days and weeks after the children disappeared, the people of the camp gathered themselves up in the dusk and waited for the stars to come out. And when the stars came out and flickered on the black wash of the sky, the people were filled with wonder—and a kind of loneliness. Some of them made exclamations, but most remained silent and respectful, reverent even. In the hold of such events there is little to be said. Then a great storm descended on the hills, and the sky roiled for four days and four nights, and there were no stars to be seen. After that, the people did not convene in the same way, for the same purpose. They went on with their lives as if nothing had happened. Even the parents of the lost children went on with their lives, as if nothing had happened. Of course there was at first the question of whether or not they ought to grieve. It was decided that they ought not, and no one held them up to scorn; no one blamed them in the least. Only old Koi-ehm-toya, one late morning when the snow swirled down and there was a general silence in the camp, emitted a series of sharp tremolo cries and cut off two fingers on her left hand.*

*But the boy was seen. One by one, hunters returned from the woods with stories in which a bear figured more or less prominently. Sometimes the bear was said to have run upon its hind legs. Sometimes it was said to have approached the hunter gladly, with eager good will, as if it had no sense of danger whatsoever. Sometimes it was said to have been defined in a strange light, as if a blue, smoky shadow lay behind it. One hunter, a man with a withered neck, was so deeply enchanted by the bear's behavior that upon its approach he could do nothing but stand with his arms at his sides. The bear came upon him, breathed the scent of camas upon him, and laid its great flat head to the hunter's genitals. In a strange moment in which there was no fear on either side, there was recognition on both sides, the hunter said. The bear cried in a human voice.*

*Then, too, a Piegan woman whose name was Thab-san, who had been captured by the Kiowas in the Antelope Plains, told the following story:*

**One night there appeared a boy child in the Piegan camp. No one had ever seen it before. It was not bad-looking, and it spoke a language that was pleasant to hear, but none could understand it. The wonderful thing was that the child was perfectly unafraid, as if it were at home among its own people. The child got on well enough, but the next morning it was gone, as suddenly as it had appeared. Everyone was troubled. But then it came to be understood that the child never was, and everyone felt better. "After all," said an old man, "how can we believe in the child? It gave us not one word of sense to hold on to. What we saw, if indeed we saw anything at all, must have been a dog from a neighborhood camp, or a bear that wandered down from the high country."**

*Tsoai, the great stump of the tree, stood against the sky. There was nothing like it in the landscape. The tallest pines were insignificant beside it; many hundreds of them together could not fill its shadow. In time the stump turned to stone, and the wind sang at a high pitch as it ran across the great grooves that were set there long ago by the bear's claws. Eagles came to hover above it, having caught sight of it across the world. No one said so, but each man in his heart acknowledged Tsoai, and the first thing he did upon waking was to cast his eyes upon it, thus to set his belief, to know that it was there and that the world remained whole, as it ought to remain. And always Tsoai was there.*

▲ ▲ ▲

In the clearing, he belonged. Everything there was familiar to him. He began to move toward the woods with the others. They were laughing, and they drew away from him. He followed, and they began to shout, taunting him, entreating him to play the game, and Loki began to run. "Set, Set!" they shouted. "The bear, the bear!" and ran. And he ran after them. "Yes. I am Set," Loki called out, flailing his arms and chuffing his breath; he was ferocious. In the trees now, he gained ground. The girls were breathing hard, glancing back and squealing. Suddenly he slowed and began to stagger and reel. Something was wrong, terribly wrong. His limbs had become very heavy, and his head. He was dizzy. His vision blurred. The objects on the ground at his feet were clear and sharply defined in his sight, but in the distance were only vague shapes in a light like fog. At the same time there was a terrible dissonance in his ears, a whole jumble of sound that came like a blow to his head. He was stunned, but in a moment the confusion of sounds subsided, and he heard things he had never heard before, separately, distinctly, with nearly absolute definition. He heard water running over stones, impressing the rooted earth of a bank beyond stands of undergrowth strummed by the low, purling air, splashing upon a drift of pine needles far downstream. He heard leaves colliding overhead, the scamper of a

squirrel deep in the density of trees, the wind careening against an outcrop of rocks high on the opposite slope, the feathers of a hawk ruffling in a long stream of the sky. It was as if he could detect each and every vibration of sound in the whole range of his hearing. And the thin air smarted in his nostrils. He could smell a thousand things at once and perceive them individually. He could smell the barks of trees and the rot of roots and the fragrances of grass and wildflowers. He could smell the scat of animals here and there, old and new, across the reach of the hills. He could smell sweet saps and the stench of the deaths of innumerable creatures in the earth. He could smell rain in the distant ranges, fire beyond. He could smell the oils rising to the surface of his skin, and he could smell the breath and sex of his sisters. He caught the sour smell of fear. He looked after his sisters. They too had stopped running. One or two of them had taken steps toward him. He tried to call to them, but he could not; he had no longer a human voice. He saw the change come upon their faces. He could no longer recognize them; they were masks. They turned and ran again. And there came upon him a loneliness like death. He moved on, a shadow receding into shadows.

Shadows.

# ABOUT THE AUTHOR

N. SCOTT MOMADAY IS A poet, novelist, painter, playwright, and story-teller, whose works are translated and read in French, German, Italian, Russian, Japanese, and other languages, as well as English. He resides in the American Southwest, and he is Regents' Professor of English at the University of Arizona. Among his numerous awards are the Academy of American Poets Prize, the Pulitzer Prize, and the Premio Letterario Internazionale "Mondello," Italy's highest literary award. He is a member of the Kiowa Gourd Dance Society and a Fellow of the American Academy of Arts and Sciences. He is the founder and chairman of the Buffalo Trust, a nonprofit foundation dedicated to the preservation of the sacred in Native American culture, and its transmission to Native American youth.